SILENT
EXODUS

SILENT EXODUS

Portraits of Iraqi Refugees in Exile

Photographs by Zalmaï

With an introduction by Khaled Hosseini

aperture

UNHCR
The UN
Refugee Agency

INTRODUCTION

Khaled Hosseini
Goodwill Envoy, UNHCR

For the last five years, the Iraqi story has been one of violence, upheaval, sectarian contempt, displacement, and exile. The conflict in Iraq has resulted in more than two million external refugees, with the majority of them fleeing to Syria, the rest to Jordan, Lebanon, and other countries. Tens of thousands have also made their way to Western Europe. The exodus of Iraqi refugees has created a serious humanitarian crisis, with massive numbers of people facing hunger, abject poverty, illiteracy, illness, and an increasing sense of hopelessness.

One of the tragedies of the Iraq war is how faceless and nameless its victims have become. The violence has been so rampant, so ubiquitous, that those who've suffered from it are increasingly lost in anonymity. Slowly, over the last few years, reports of the violence in Iraq have taken the form of cold statistics: the daily counts of the latest casualties, how many dead, how many injured, how many have packed their things and fled.

But Zalmaï's breathtaking photographs pull the victims out of anonymity. His pictures chronicle the suffering of the Iraqi refugees with raw, startling power. His lens unflinchingly captures the sorrow, the pain, the humiliation, anger, and fear of the Iraqi refugees. With these photos, he makes palpable a sense of the human toll of this crisis. As we look at these pages, the suffering and displacement of the Iraqi refugees is no longer an abstract idea, made more impersonal and distant by a buffer of statistics. The toll of this crisis becomes real. It becomes immediate for us when we gaze at the hollow-eyed mothers who hold pictures of their dead sons; the children scarred by bomb fires; the dead bodies carried in sheets from scenes of carnage; the families torn asunder, living in squalor and isolation, far from everything and everyone they once knew and loved.

Perhaps being Afghan and a former refugee himself enables Zalmaï to approach this material with more personal, passionate affinity. Whether that is the case or not, with this remarkable book, he gives the Iraqi refugees a face and a voice. That Zalmaï can do this is a testament to his considerable skills as a photographer, and more important, to his compassion as a humanitarian.

ON MARCH 20, 2003, AMERICAN FORCES INVADED IRAQ

BOMBING OF A SHIITE SHRINE IN SAMARRA, SPARKING

THROUGHOUT THE REGION. IN A 2008 SURVEY OF REFU-

HAD LEFT IRAQ BEFORE 2003; 44 PERCENT BETWEEN

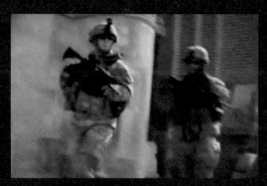
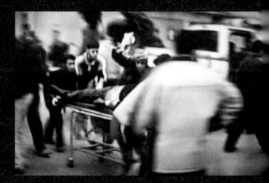
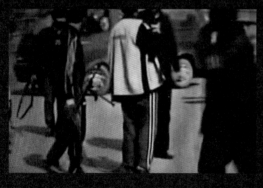
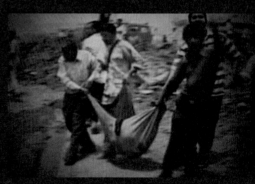
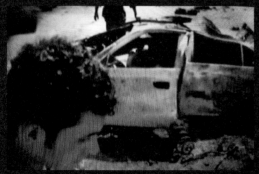
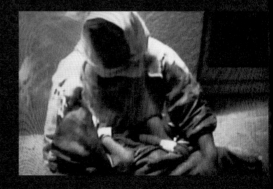

SECTARIAN VIOLENCE ESCALATED IN 2006 WITH THE

MASSIVE DISPLACEMENT WITHIN THE COUNTRY AND

GEES IN SYRIA, OF THOSE SURVEYED, SOME 2 PERCENT

2003 AND 2006; AND 54 PERCENT AFTER 2006.[1]

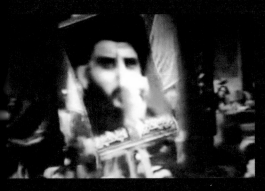

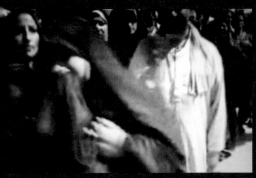 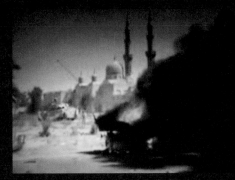

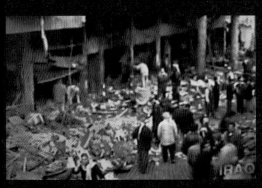

4.7 million Iraqis have been displaced.

THE
DISPLACEMENT
OF IRAQIS
FROM THEIR HOMES
IS ONE OF THE
FASTEST-GROWING
REFUGEE CRISES
IN THE WORLD.

Over two million Iraqis have fled their homeland. In addition to those who have left in search of safety in neighboring countries, approximately 2.7 million people are displaced within Iraq.

The United Nations High Commissioner for Refugees (UNHCR) estimates that at the peak of the exodus in 2007, up to sixty thousand people a month fled their homes. The *New York Times* has described the situation as "the largest exodus since the mass migrations associated with the creation of the state of Israel in 1948."[2]

Syria 1.3 million

Jordan 500,000

Lebanon 50,000

Iraq's neighbors, in particular the Syrian Arab Republic (Syria) and Jordan, have been impacted the most severely by the refugee crisis. Other countries such as Lebanon, Egypt, Iran, and other Gulf states have also struggled to absorb the many thousands seeking refuge within their borders. While Iraqis who have fled to other countries find some degree of safety there from the violence and sectarian persecution at home, as refugees they face other crushing difficulties, such as lack of access to education for their children; severely escalating prices for housing, food, and health care; few to no employment opportunities; and dwindling personal resources. In addition, they have to cope with the increasingly restrictive policies of host countries straining to accommodate the massive influx of refugees.

By the end of 2007, both Syria and Jordan, the two countries hosting over 90 percent of externally displaced Iraqis, had severely restricted access to additional refugees. Despite reports of some Iraqi refugees returning home—most having simply run out of resources—the majority remain in limbo, afraid or simply unable to return, yet faced with increasing resentment and diminishing resources and opportunities in their host countries. The conditions continue to deteriorate for Iraqi refugees. In extreme cases, refugees have been forced against their will to return to their still-unstable homeland.[3] Of those who have returned to Iraq, many have found their property occupied and suffered secondary displacement.[4]

"NEITHER THE U.S. NOR THE REST OF THE WORLD IS PAYING SUFFICIENT HEED: EXTERNAL HELP PROVIDED BY REGIONAL COUNTRIES AND MAJOR INTERNATIONAL DONORS HAS BEEN HALF-HEARTED AND WOEFULLY INSUFFICIENT."[5]

The individuals depicted in this book were photographed in Syria, Jordan, and Lebanon. Everyone who participated in this project agreed to be photographed and to have their stories told in the hope of bringing greater attention to the dire circumstances they face. First-person statements are taken from interviews with refugees; names have been changed or omitted to protect the subjects' identities. The photographs and interviews here were shot and conducted in 2007.

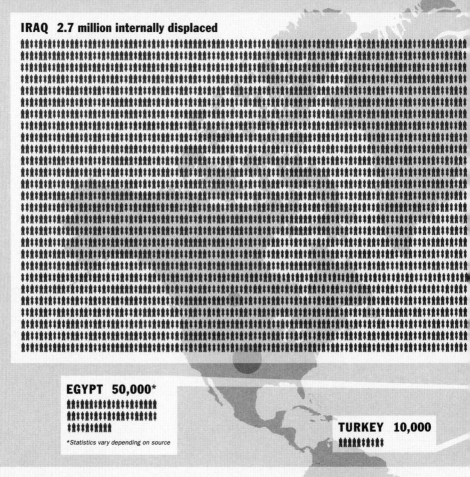

IRAQ 2.7 million internally displaced

EGYPT 50,000*

*Statistics vary depending on source

TURKEY 10,000

JORDAN 500,000

GULF STATES 200,000

4.7 million displaced Iraqis

SYRIA 1.3 million

LEBANON 50,000

IRAN 57,000

GERMANY	36,200
SWEDEN	23,600
UNITED KINGDOM	22,000
NETHERLANDS	21,800
UNITED STATES	19,800
AUSTRALIA	11,100
DENMARK	9,900
NORWAY	8,700
SWITZERLAND	5,000
CANADA	4,000
FINLAND	1,600
ITALY, FRANCE	1,300
HUNGARY, BULGARIA, AUSTRIA	1,200

Greece, New Zealand, Armenia, Romania, Ireland: less than 1,000

Latest figures available are for January 1, 2007. For most European countries and the U.S., UNHCR estimates are based on asylum-seeker recognition and resettlement arrivals since 1997. For Canada, Australia & New Zealand, UNHCR estimates are based on asylum-seeker recognition and resettlement arrivals since 2002.

1,000 IRAQIS

ONE IN FIVE IRAQIS HAS BEEN DISPLACED. FAILURE TO ADDRESS THE NEEDS OF THESE IRAQIS WILL HAVE DRAMATIC IMPACTS ON SECURITY INSIDE IRAQ.[6]

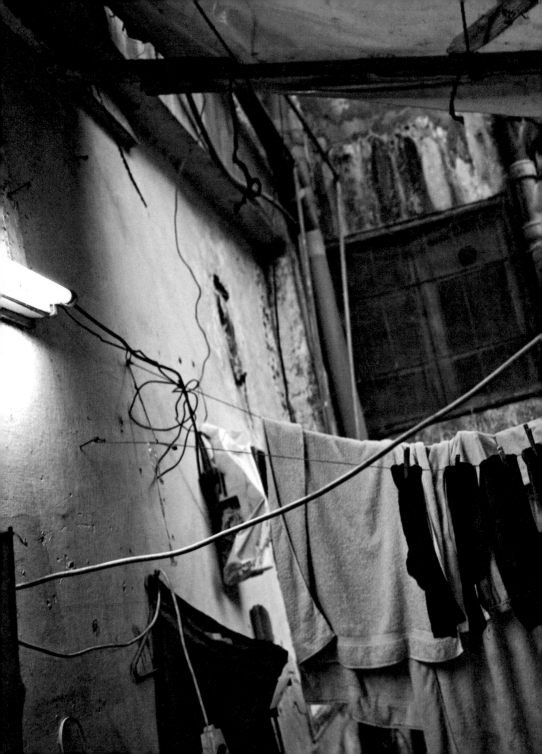

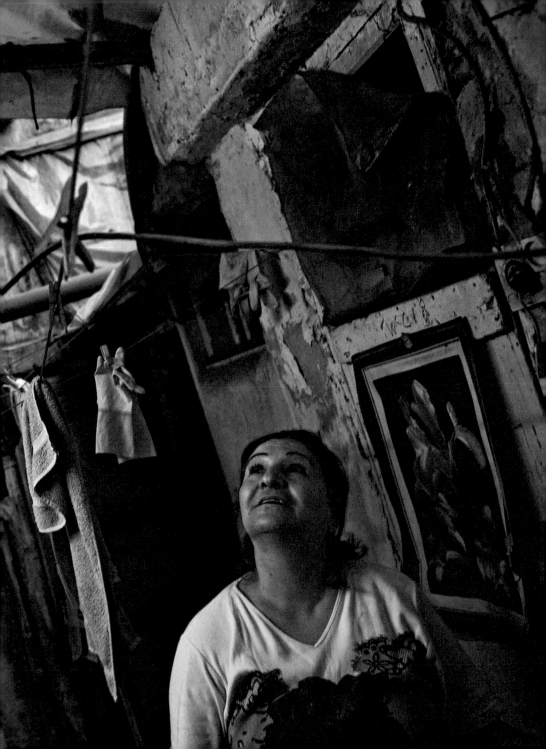

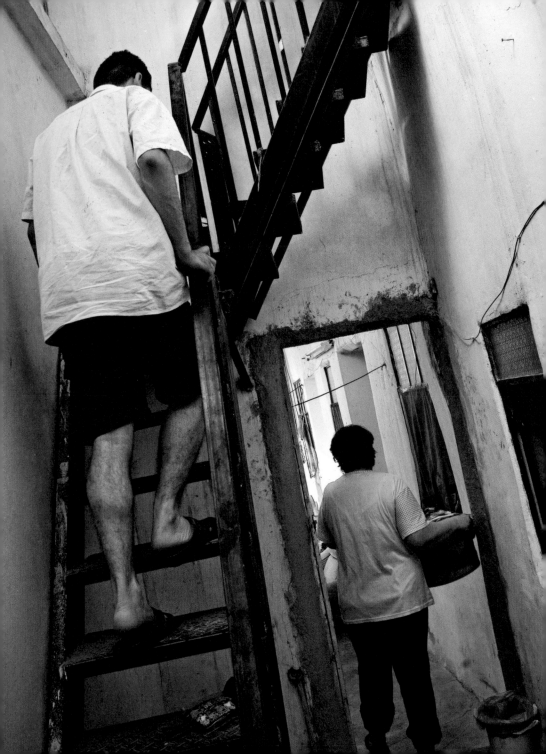

"If you sat in your house, you were not safe; if you went out, you were not safe. . . . First there was the kidnapping, then the attacks by mortar shells. . . . It was hell."

I used to have my own company and employed five people painting billboards. My wife worked at the Central Bank. She was enrolled at the university but started to receive threats because she used to travel between Sunni and Shia areas. In October 2006, our four-year-old son Omar was kidnapped and held for twenty days. He was kidnapped by Shia militia. We are a Sunni family, and Omar is a Sunni name. Other than his name, there's no reason why he had been targeted. They killed five thousand people—children and men—called Omar. First they targeted the adults called Omar, then the children called Omar. We were able get him back by paying the kidnappers $40,000.

We had received no threats or warnings before Omar was kidnapped. We also knew a young man, an architect, who was kidnapped and killed because he was called Omar. It is not a religious thing; they did this because they say the Sunnis were pro-Saddam.

After Omar was kidnapped, we decided that we wanted to leave Iraq. If you sat in your house, you were not safe; if you went out, you were not safe. When you sent your child to school, you did not know if he or she would return. First there was the kidnapping, then the attacks by mortar shells. The militias came at night to kidnap people from their homes. During each of the prayers, five times a day, there were mortar shells. It was hell.

We left Iraq in December 2006. I sold the car, our land; and our parents helped us to raise the funds. We went to Syria and rented a house, but there were no jobs. A friend of my wife's called to tell us that there were work opportunities in Lebanon. One week later, I entered Lebanon on a one-month tourist visa. That visa has expired, and it has been difficult to renew.

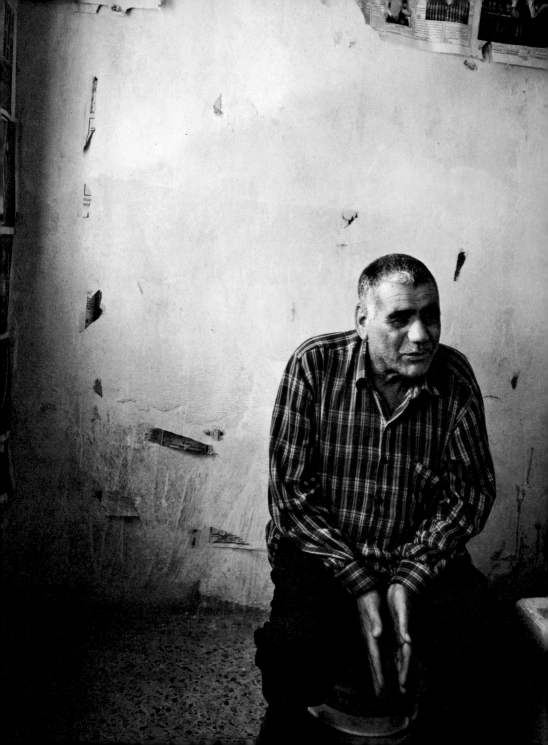

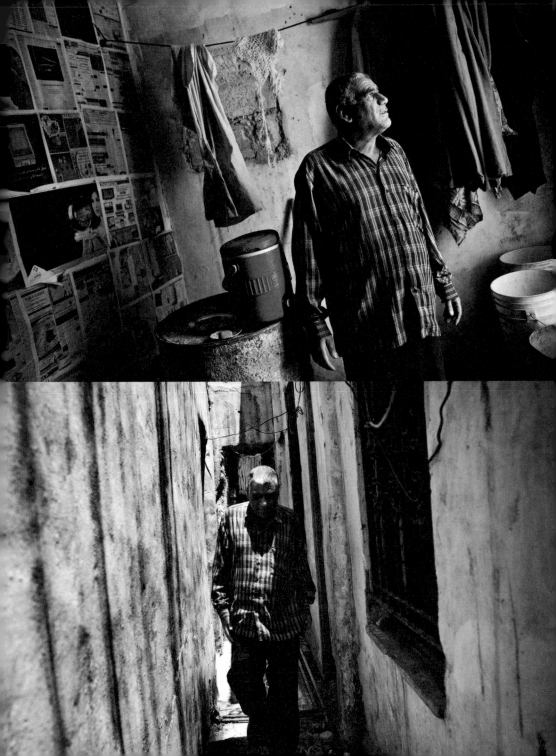

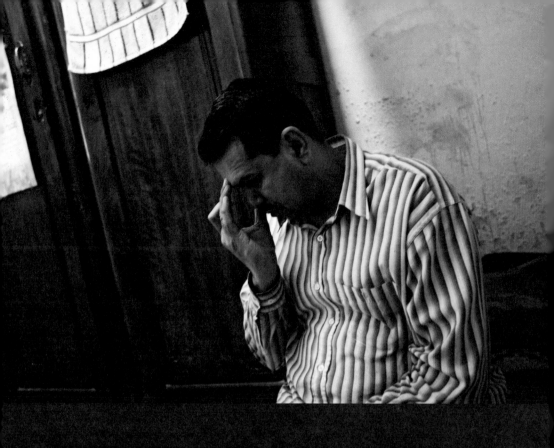

"The Shia Iraqis flee
from Sunni violence,
and the Sunni Iraqis
flee from Shia violence."

The basis of society in Iraq has been destroyed: there are no more teachers or judges. I used to be a teacher. I originally left Iraq because I was being tracked by Saddam's political regime. I returned to Baghdad after his demise. We thought that after the fall of the regime it would change, but it did not get better. I was forced to return to Syria.

The Shia Iraqis flee from Sunni violence, and the Sunni Iraqis flee from Shia violence: both groups are no longer in danger once they cross the Syrian border. The sectarian violence has not traveled to Syria yet.

Here I cannot work as a teacher. Instead I work in a shoe shop, from 10:00 a.m. to 11:00 p.m. every day, seven days a week, no holidays. I earn about $4 a day [or $120 a month]. The rent alone is $80 per month, and I share this small room with my friend Hossein. I eat potatoes every day for lunch. Hossein works in a plastics factory, from 9:00 a.m. to 11:00 p.m., seven days a week, without holidays. He earns about the same as I do. For the work we do, Syrians would earn at least $200 a month, or more, with the right experience.

A week ago, someone from the Syrian security forces came and told me I had to quit my job. Luckily, the owner of the shop intervened. He said, "We all know that there are Iraqis working everywhere in Syria, even at the Four Seasons Hotel." I was able to keep my job. Until a year ago, relations between Iraqis and Syrians were fine. But now there are so many Iraqis arriving, and prices keep rising. The Syrians blame the Iraqis for the rise in the prices of food, rent.

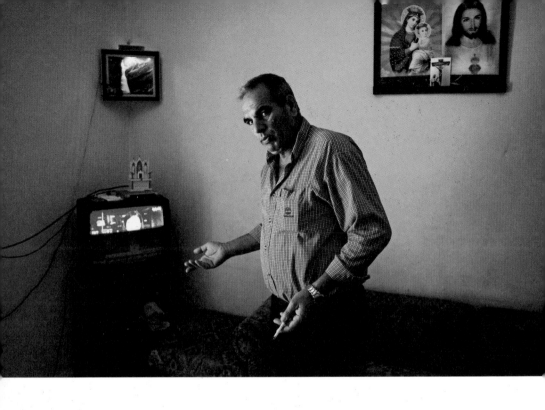

"I don't know why they targeted me. I wouldn't say that I was targeted by Christians or Muslims— they were gangsters and militias."

They killed my brother's son in April 2004. In December 2004, my house was hit by a Molotov cocktail, and my leg was severely burned. I don't know why they targeted me. I wouldn't say that I was targeted by Christians or Muslims—they were gangsters and militias.

They killed my own son in front of my house in September 2005. He was working on a truck to take water to the Ministry of Interior forces. He was threatened, and told to leave his job because he worked at a government site. He decided to leave the job, and went back to the site to return the truck. The militias saw him and thought that he was still working, so they killed him.

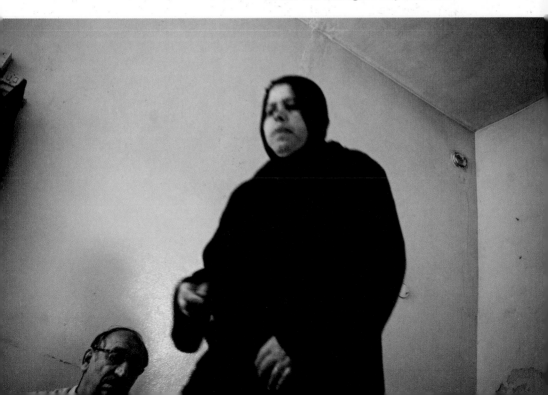

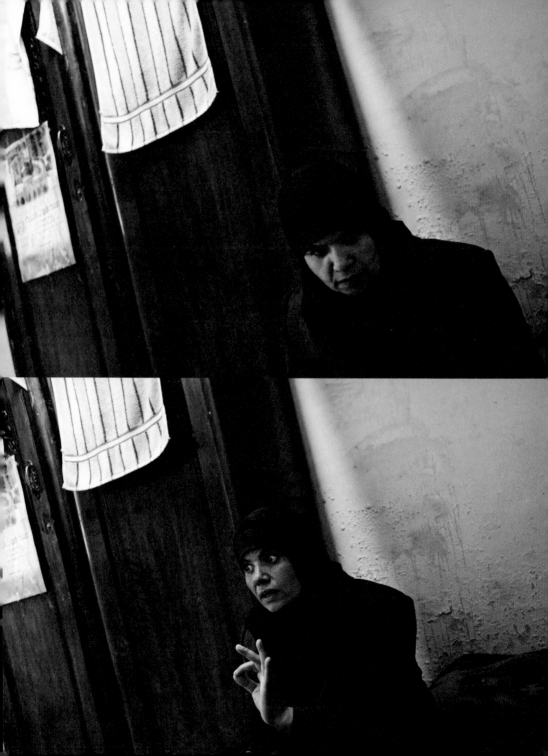

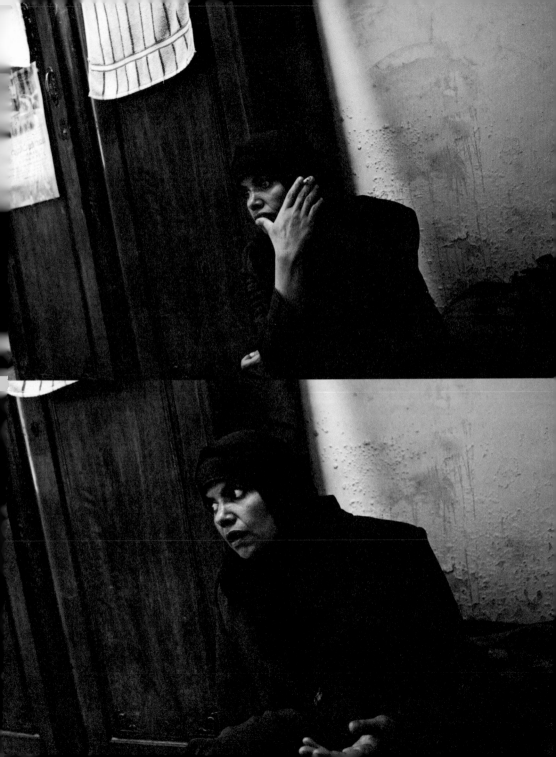

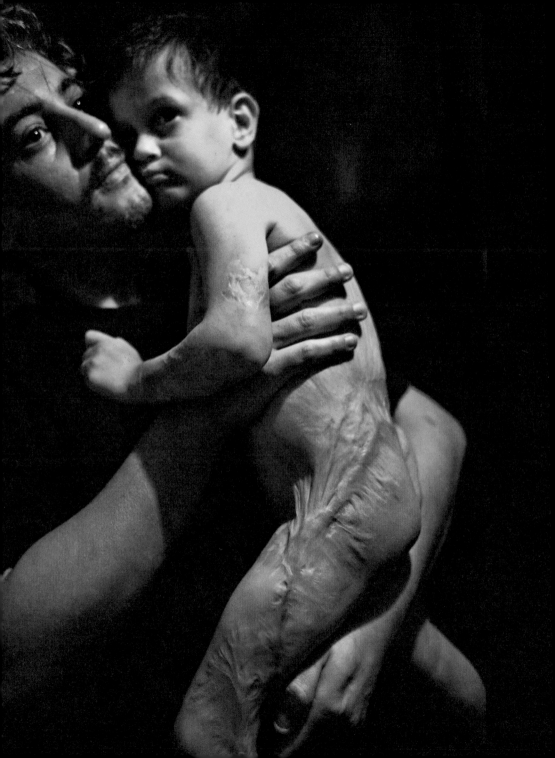

"We left Iraq after our house was bombed. . . . We managed to leave so that we could seek treatment for our son, who was very badly burned in the bombing."

I used to be a taxicab driver. Here, I am not allowed to work. I don't even dare go outside for fear of deportation. I have a wife and four children. My wife works in the streets of Amman selling cigarettes. We live in an apartment building in an impoverished neighborhood where many other refugees live. We are a family of six in a very small room, measuring just over two hundred square feet, with no windows.

We left Iraq after our house was bombed. With the help of a friend, we managed to leave so that we could seek treatment for our son, who was very badly burned in the bombing. He needs surgery very soon or he will not be able to walk again. The surgeries will cost a total of $30,000. I don't know how we will pay for that without secure employment or other help.

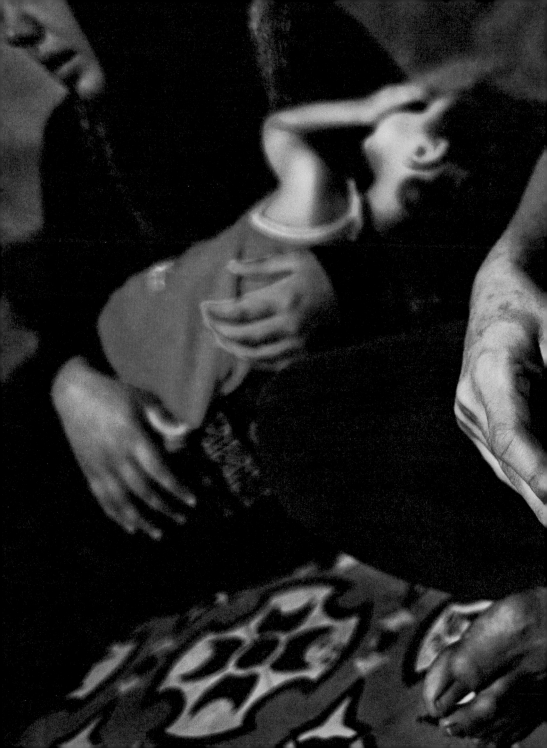

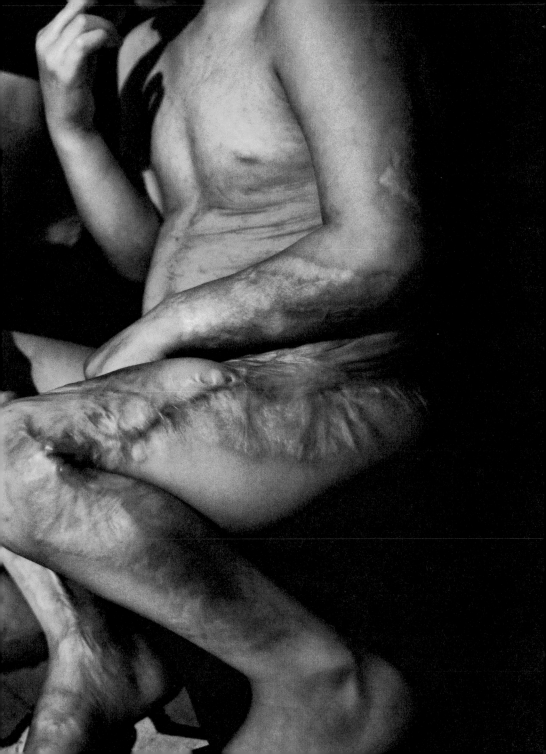

"After my son was killed, we were warned that we should leave Baghdad, otherwise we would be killed too."

My husband used to work for the Information Ministry in Iraq and retired in 1989. We had three sons, but our oldest son was killed by Iraqi militias in 2005. [After that], we were warned that we should leave Baghdad, otherwise we would be killed too. We moved to a village north of Baghdad and lived there for eleven months. Then we paid someone to get passports for us, and we left.

Our two surviving sons are seventeen and nineteen. They don't go to school because it's too expensive: you need money for uniforms, school supplies, and transportation. Every two months I go to Baghdad to collect my husband's retirement payment and food, which we are able to get thanks to food coupons.

We also have to go to the border every month to renew our visas. We leave at 5:30 a.m., and reach the border by 10:30 a.m. Once we cross, we wait at the Iraqi border for at least three hours, or sometimes four or five. The Americans search all the cars. Once you're inside Iraq, you have to turn around straight away; it takes two to three hours to cross the Iraqi border. Then there is again a long queue to cross the Syrian border, around four hours. And then it is at least another five hours to get back home. Sometimes at the Iraq border, the Americans tear up someone's passport, or they tell you that your passport is fake and return you to the Syrian border.

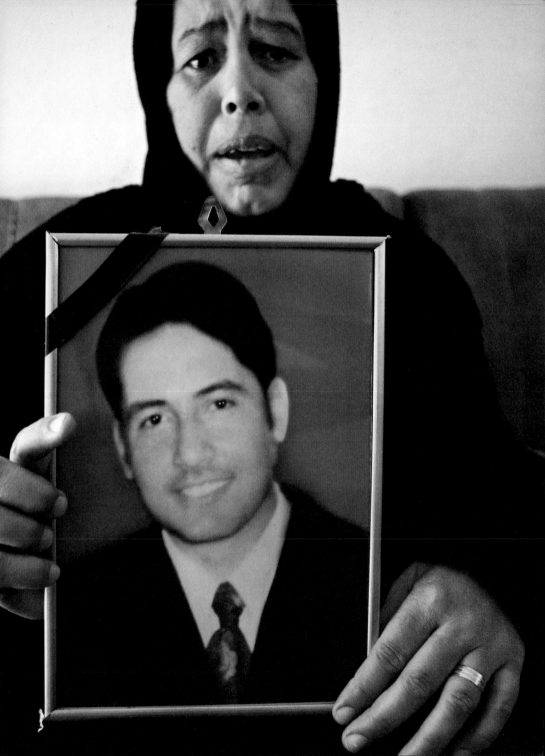

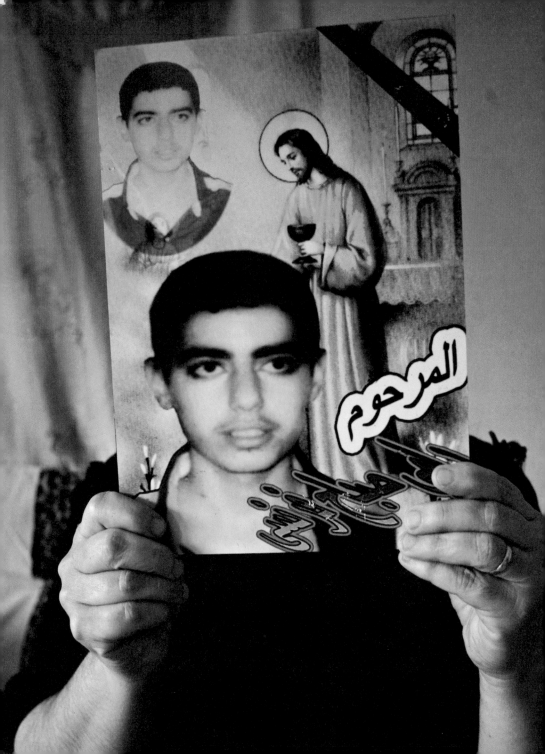

ACCORDING TO A RECENT UNHCR SURVEY OF IRAQI REFUGEES IN SYRIA:[7]

77 PERCENT REPORTED BEING AFFECTED BY AIR BOMBARDMENTS AND SHELLING OR ROCKET ATTACKS.

80 PERCENT REPORTED WITNESSING A SHOOTING.

68 PERCENT SAID THEY EXPERIENCED INTERROGATION OR HARASSMENT BY MILITIAS OR OTHER GROUPS, INCLUDING DEATH THREATS.

16 PERCENT HAVE BEEN TORTURED.

72 PERCENT WERE EYE WITNESSES TO A CAR BOMBING.

75 PERCENT KNOW SOMEONE WHO HAS BEEN KILLED.

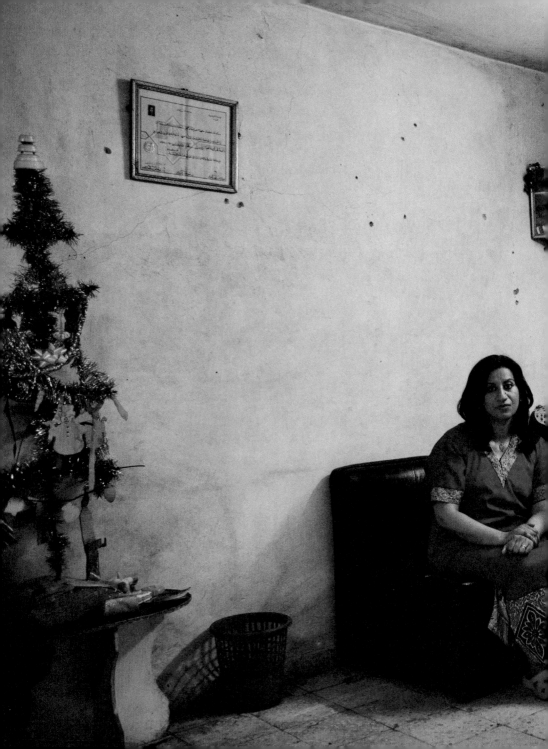

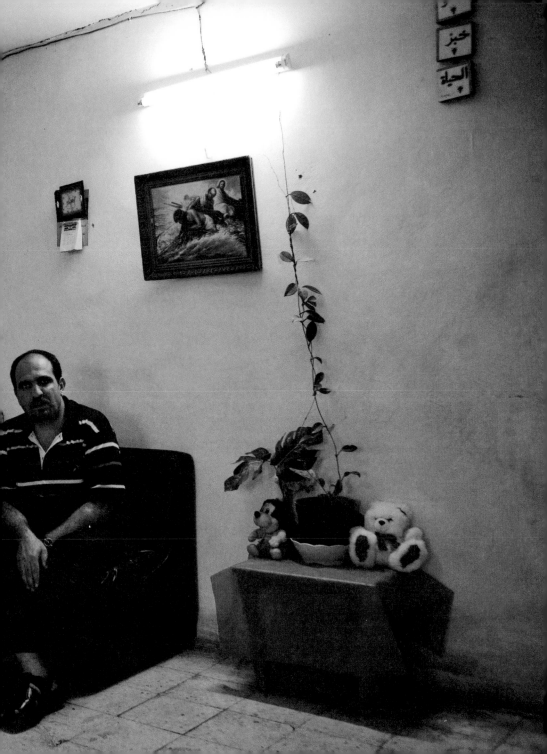

"'Today you are here, but tomorrow you might be gone.'"

Our family is Christian. Because of this, we were threatened. On top of this, my wife worked for a bank in Baghdad; the American forces were involved in restructuring the bank. Because of these alliances, we were forced to leave Iraq. Before that, we were part of the middle class. Our life was much better.

My wife is a university graduate; she was able to find a job in the traffic department in Jordan for a year and a half. In April 2007, however, she received a letter from the Jordanian Ministry of the Interior, which informed her that she was no longer allowed to work.

I cannot find a sponsor to apply for residency. Employers are reluctant to sponsor Iraqis. They say, "Today you are here, but tomorrow you might be gone."

I first fled Iraq in 1999 and arrived in Lebanon in 2000. I had been chased by members of Saddam Hussein's former regime. I stayed in Lebanon illegally until the fall of the regime and was smuggled back into Iraq in November 2003.

My brother worked for the police forces. He asked me to join him, and I accepted. Not long after, he went to Baghdad and was killed. We don't know exactly how he died, but he was probably shot in the head. I started to receive death threats.

One day, I came home from work and couldn't find anyone at the house. My wife was pregnant. The neighbors told me that she was in the hospital. Apparently, someone had thrown a sound grenade near our house. We lost the baby. We decided then to leave Iraq and were smuggled out without passports. I returned with my wife to Lebanon in October 2006.

Even after I had fled to Lebanon, my parents in Iraq continued to receive threats from terrorists. In these threats [like the one pictured on the following pages], they mention me by name. They know that I have left Iraq, and now I am afraid, even in exile. I avoid going near Sunni areas. I had to leave my job for fear of being attacked.

"Even after I had fled to Lebanon, my parents in Iraq continued to receive threats from terrorists."

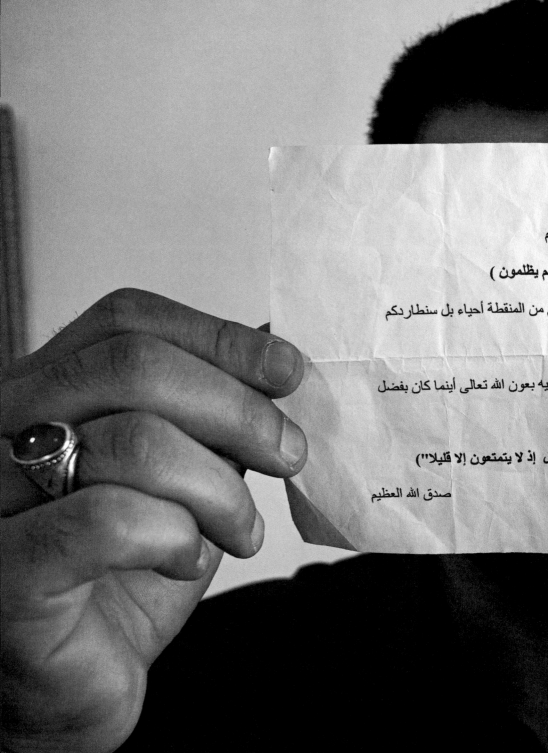

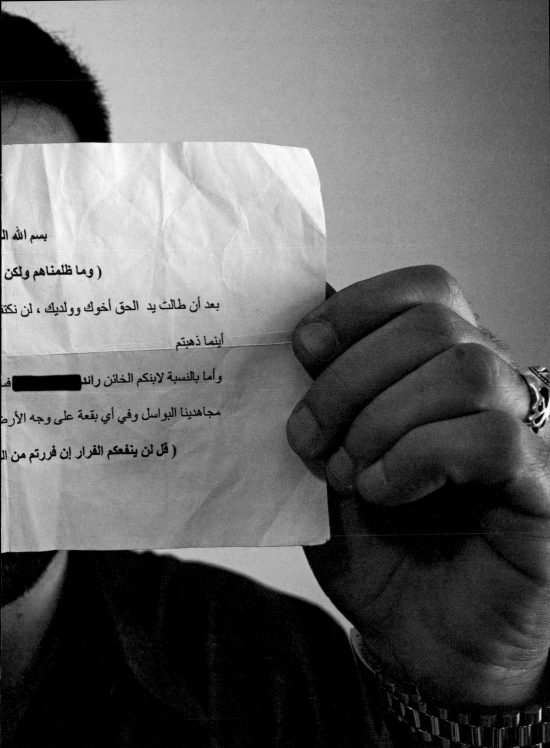

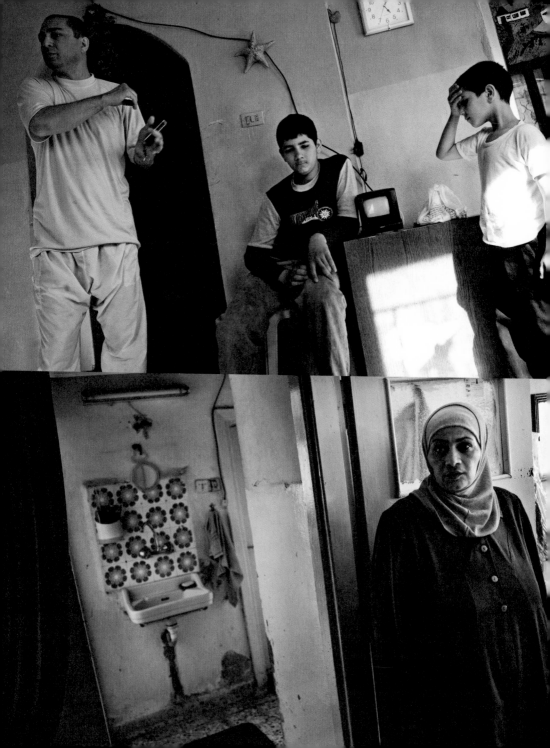

"There is no future for my children here. The house is like a prison for us—we cannot leave for fear of arrest and deportation."

In Iraq I worked for a couple of different nongovernmental organizations (NGOs), helping to provide assistance to internally displaced persons and to assist in Iraqi elections. I received many death threats as a result of my work. One night I was shot at while driving home. My family was so terrified that we fled to Baghdad. In Baghdad, I continued to receive threats. We decided we had to flee the country in order to save our lives.

My family and I, including four children who range in age from six to sixteen, have been living here for over two years. None of the children can go to school because our family is here illegally.

There is no future for my children here. The house is like a prison for us—we cannot leave for fear of arrest and deportation. If my situation does not change soon, I'm ready to risk my life to seek refuge in a Western country.

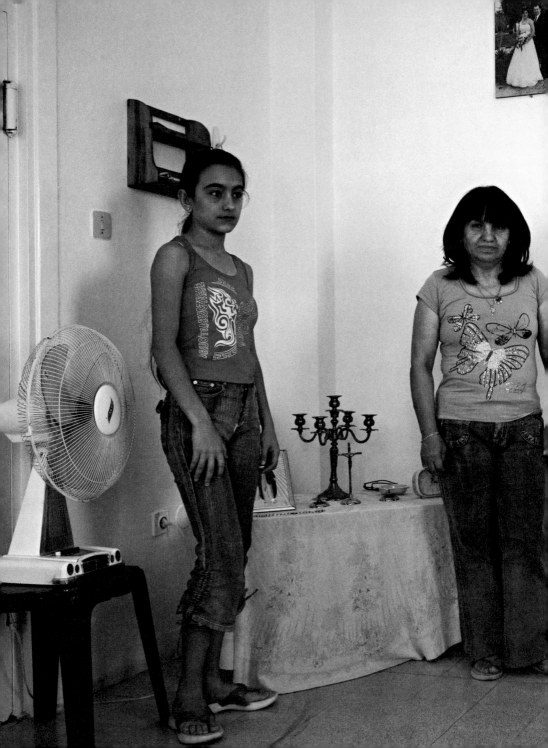

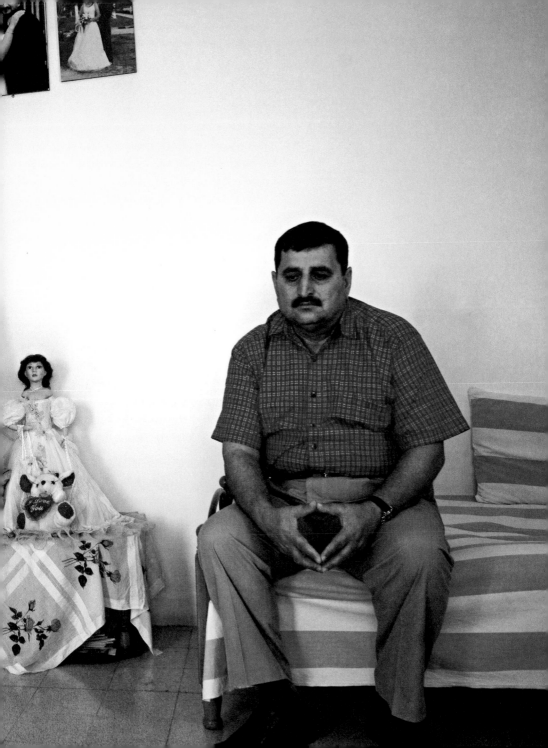

According to a Human Rights Watch report, "Iraqi refugees in Lebanon currently enjoy only very limited protection. . . . Lebanon is not a party to the 1951 United Nations Convention Relating to the Status of Refugees (Refugee Convention) or to the 1967 Protocol Relating to the Status of Refugees. It has no domestic refugee law. Instead, people who enter Lebanon illegally for the purpose of seeking refuge from persecution, or who enter legally but then overstay their visas for the same purpose, are treated as illegal immigrants and are subject to arrest, imprisonment, fines, and deportation."[8]

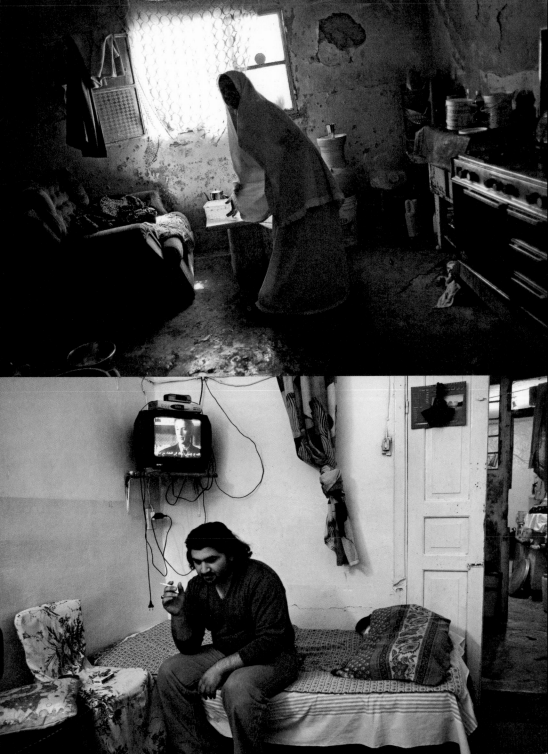

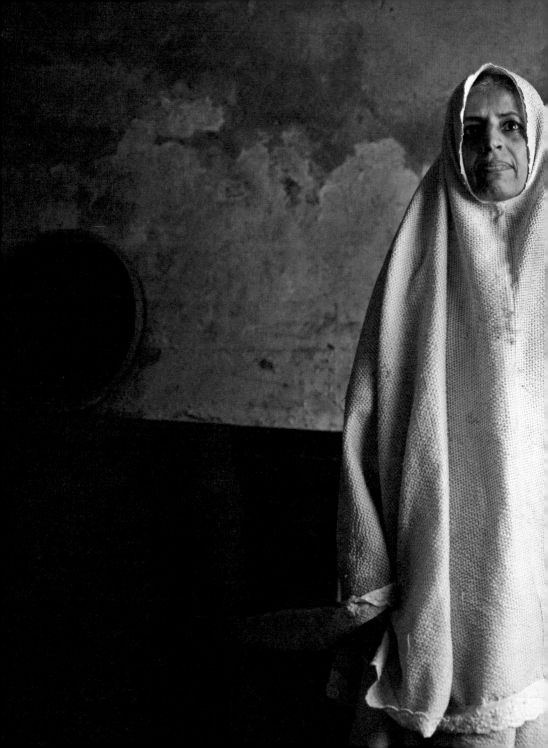

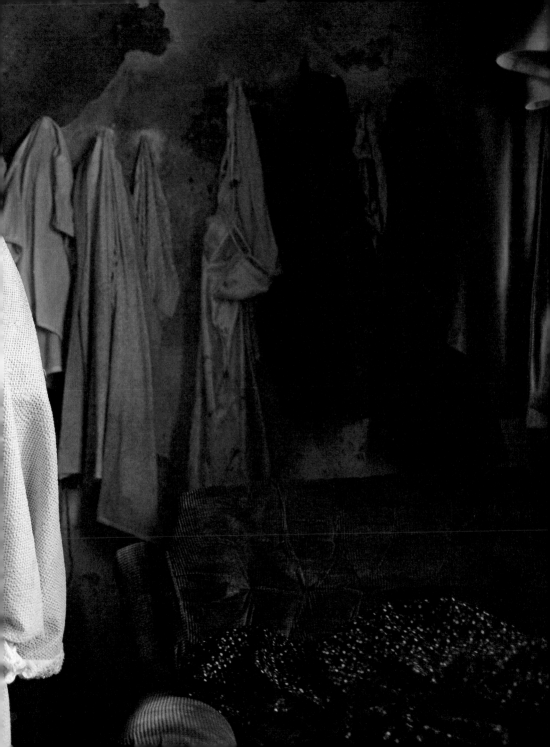

"If my friends and family do not send money from abroad, we have nothing to eat."

In Iraq, I had a nursery for trees and plants, but we lost it all when we came here. My daughter cannot attend school because we are here illegally. If my friends and family do not send money from abroad, we have nothing to eat.

I tried to register as an asylum seeker directly through the Australian government, a process that can be done online. Despite the fact that Australia is the one world government through which people like me can seek asylum directly, my application has been turned down seven times.

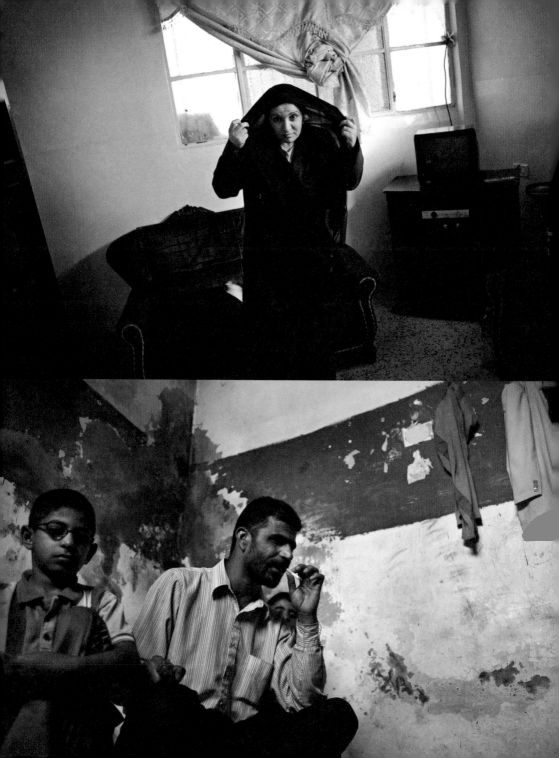

"We are like birds in a cage."

I arrived in Lebanon with my family five years ago. Without the help of a charitable organization, my son would not be able to go to school. We are like birds in a cage. My own youth was lost in wars. All I ask is for a secure future for my children.

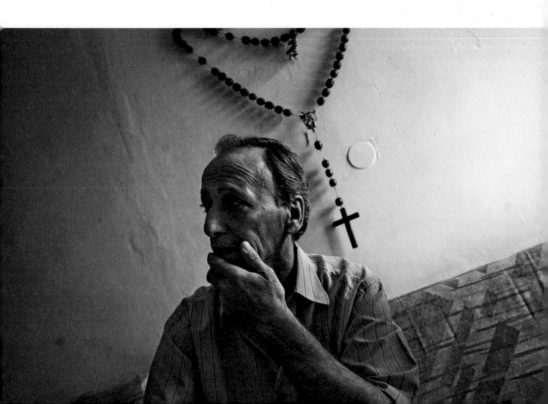

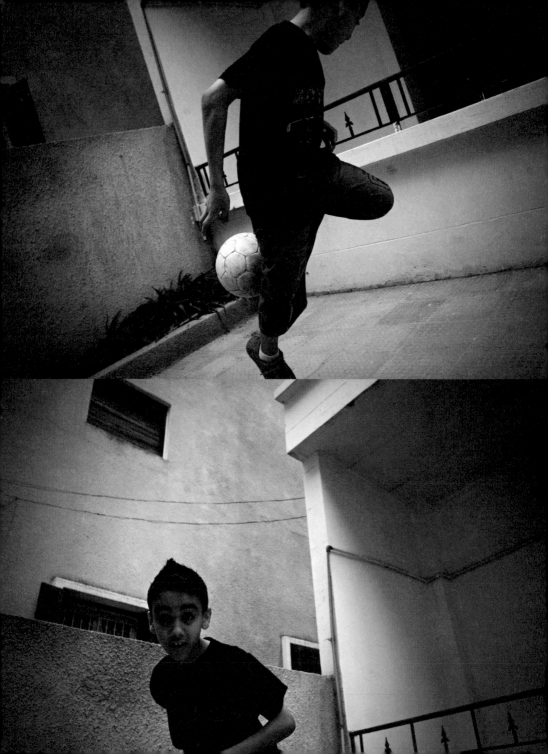

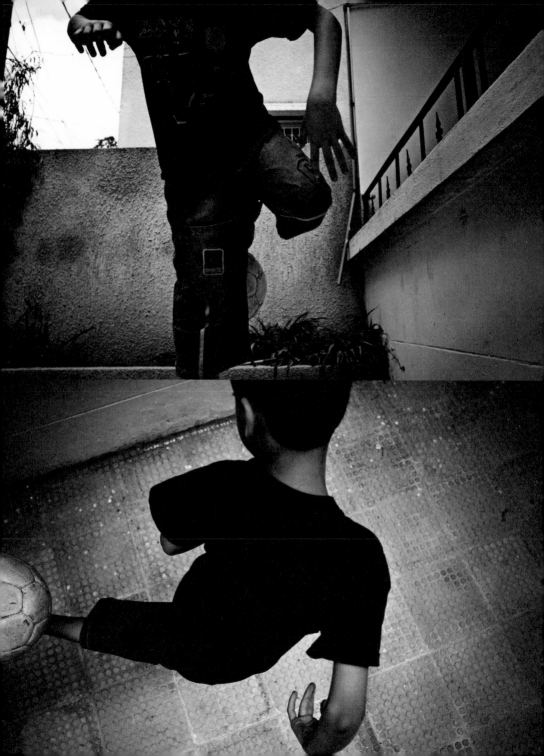

ILLITERACY IS RAPIDLY SPREADING AMONG REFUGEE CHILDREN FROM IRAQ.

A UNHCR research study in Lebanon, conducted by the Danish Refugee Council, surveyed 1,020 Iraqi households. The study found that "enrollment in schools for children aged between six to seventeen years old was only 58 percent. Ten percent of Iraqis surveyed are suffering from chronic illnesses. . . . Finally, more than half of the respondents reported never feeling safe in Lebanon."[9]

In other briefings, UNHCR has stated that only thirty-two thousand of the hundreds of thousands of Iraqi refugee children in Syria are actually in school. Initially, Syria, with 1.3 million Iraqis, was the only country in the region that allowed free public school access for all Iraqi children. Recently, Jordan also agreed to give Iraqi refugee children access to education. But there simply isn't enough space to take them all in.

"A WHOLE GENERATION OF IRAQI CHILDREN IS IN DANGER OF MISSING OUT ON AN EDUCATION."[10]

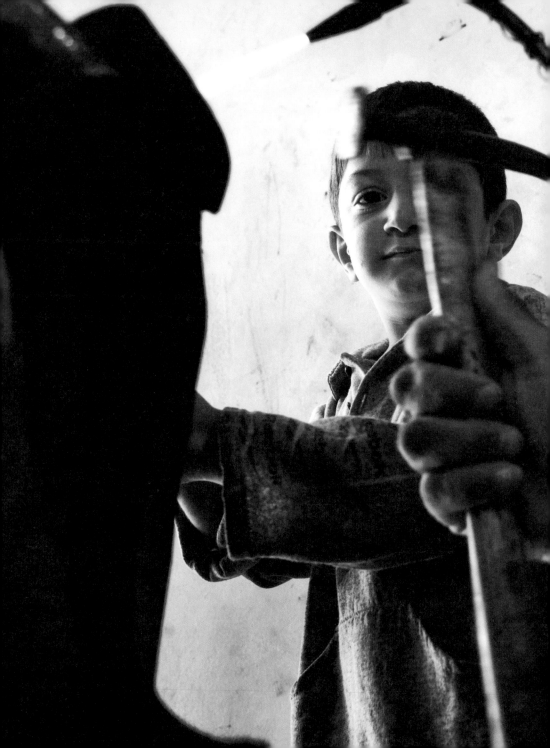

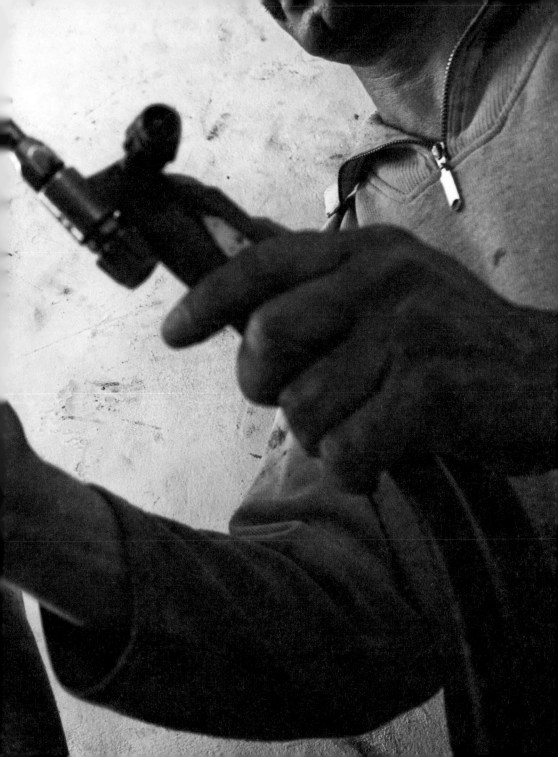

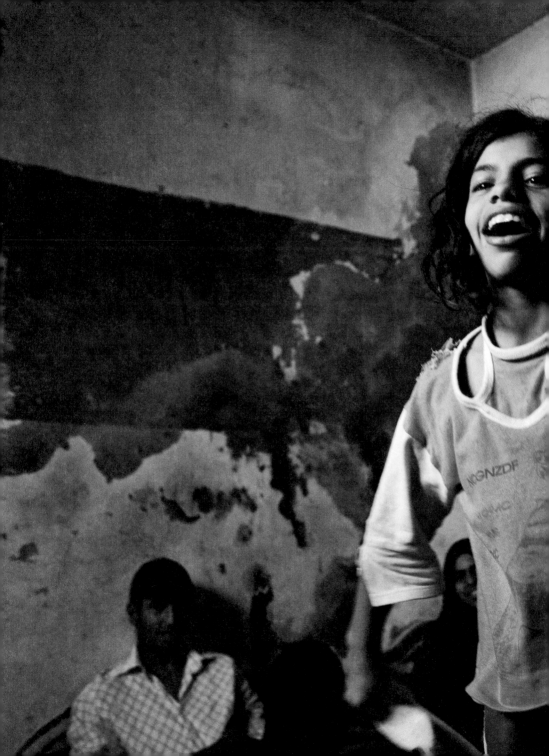

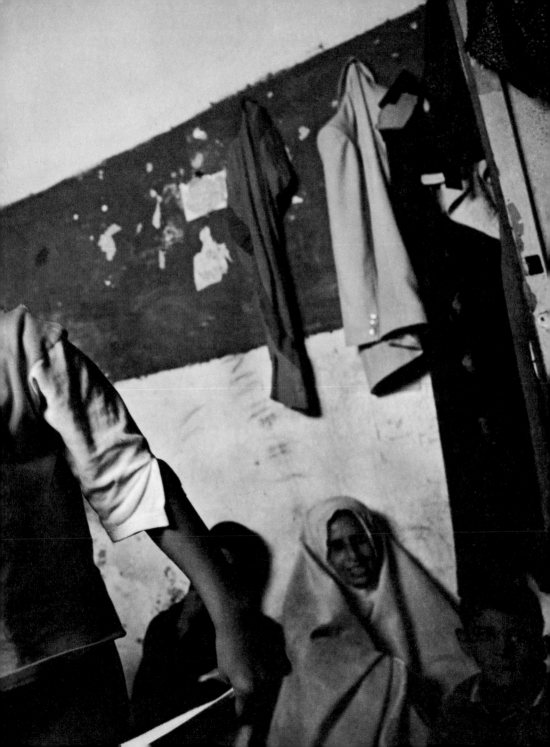

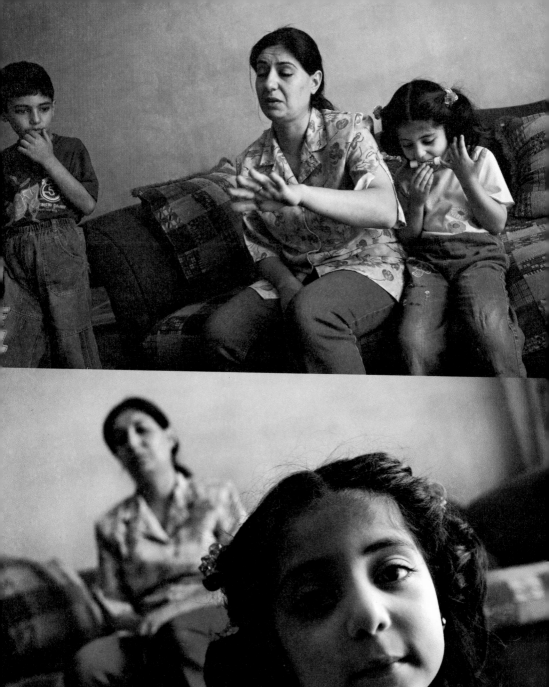

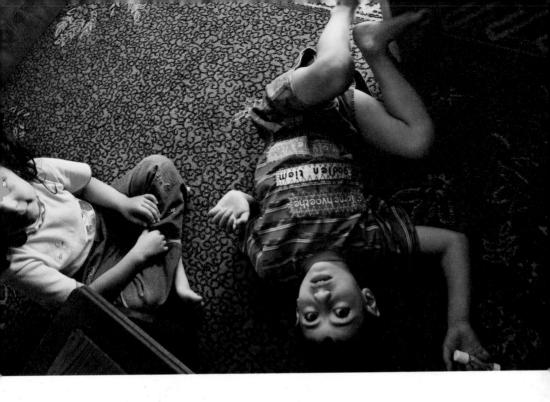

"We cannot begin to imagine returning to our war-torn country; the future of our family—like so many others—is bleak."

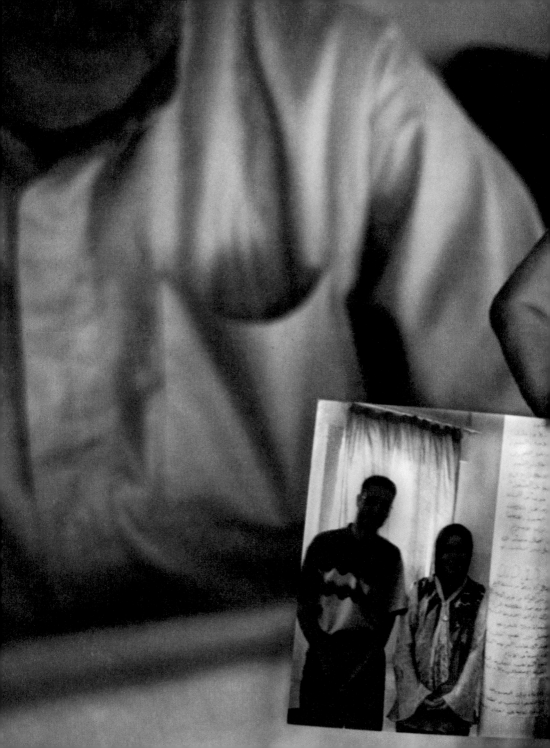

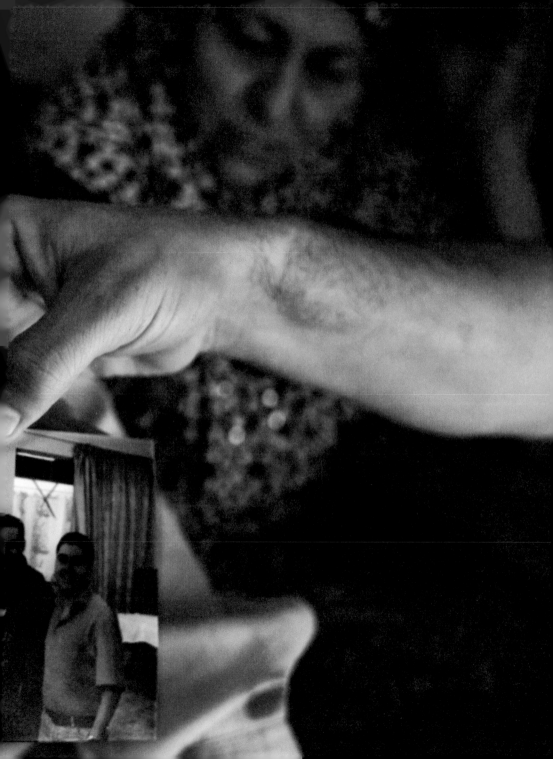

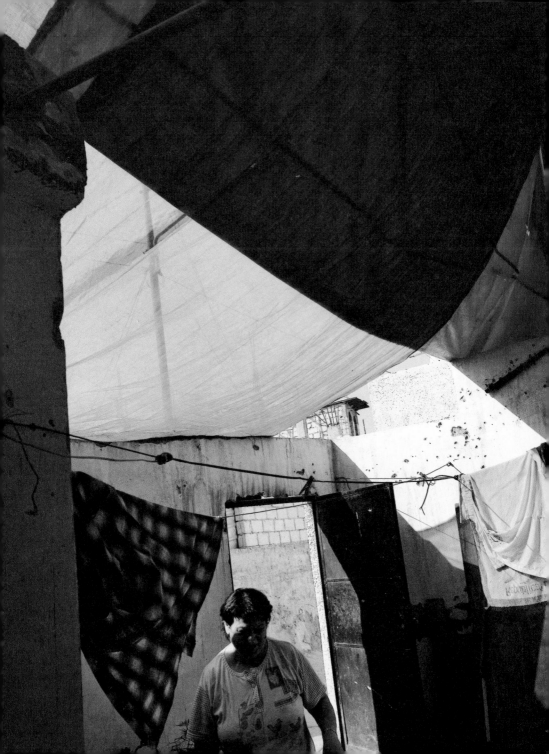

UNHCR ASSERTS THAT "IN SYRIA ALONE, SOME **36.3** PERCENT OF THE **47,000** REGISTERED WITH THE AGENCY SINCE THE BEGINNING OF 2007, ARE IN NEED OF SPECIAL ASSISTANCE. OF THEM, ABOUT **25 PERCENT** REQUIRE LEGAL OR PROTEC- TION ASSISTANCE, INCLUDING MANY VICTIMS OF TORTURE. NEARLY **19 PERCENT** OR **8,738** PEOPLE HAVE A SERIOUS MEDICAL CONDITION."[11]

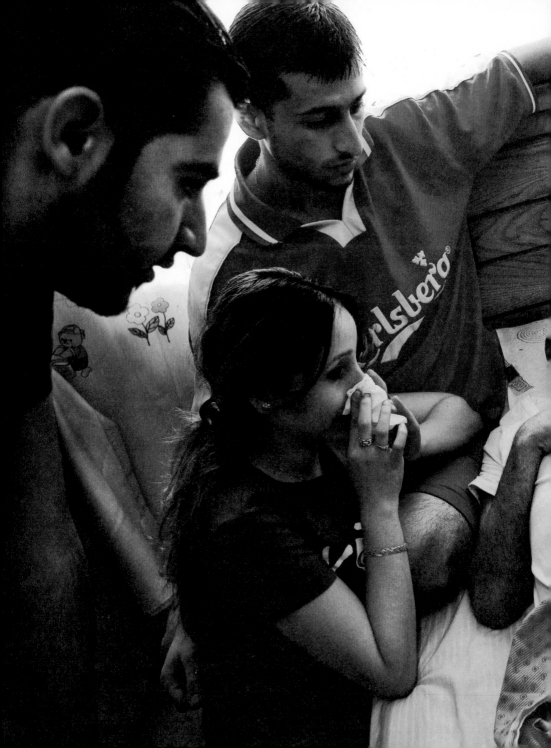

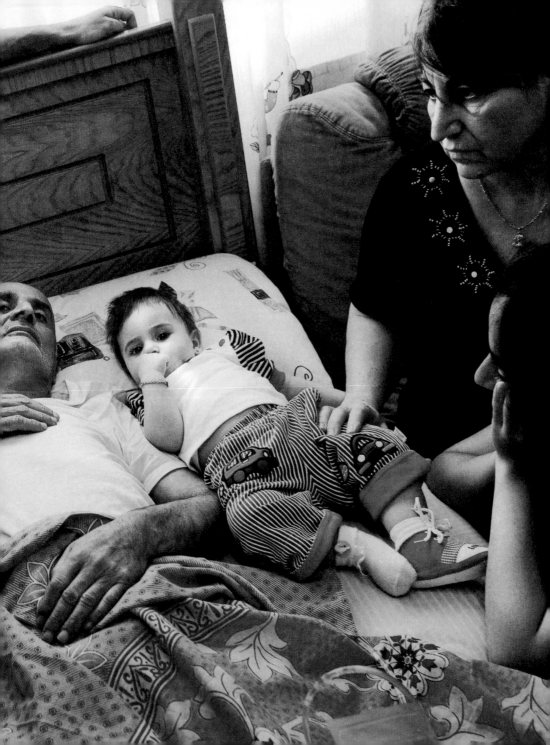

"Without hope, a human being cannot live. We do not have much hope."

In 1983, I lost most of my sight because of chemical weapons during the Iraq-Iran War. Today, my son is ready to give me one of his own eyes! But the cost of the surgery is prohibitively expensive. I need a lot of money for the surgery. In Iraq, I received a monthly medical stipend for my disability. Even here, I used to receive $200 in compensation every two months, but in the last six months I've been unable to receive even this much-needed money.

Without hope, a human being cannot live. We do not have much hope. Sometimes, I sell cigarettes in the street for money, but I'm afraid they'll kick me out, so I don't even dare do that these days. Luckily one of my daughters is able to get occasional work as a babysitter to earn some money for the family. Four of our children are currently enrolled in public school here, but the school has told us that our children will not be able to attend next year.

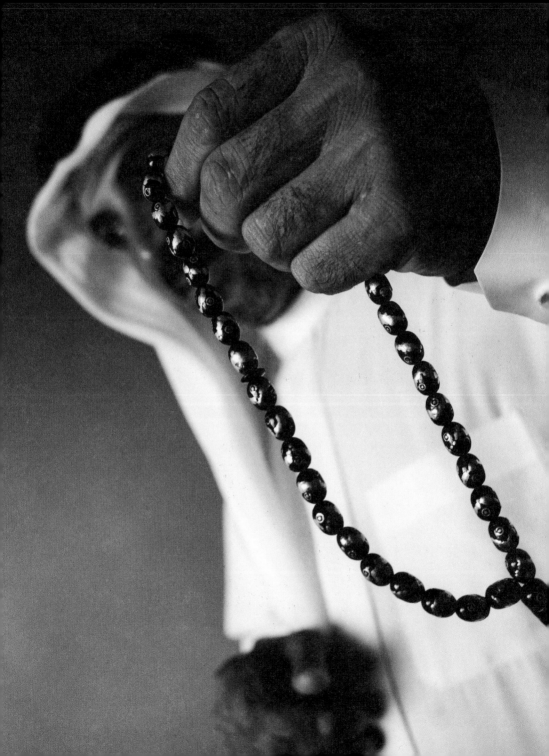

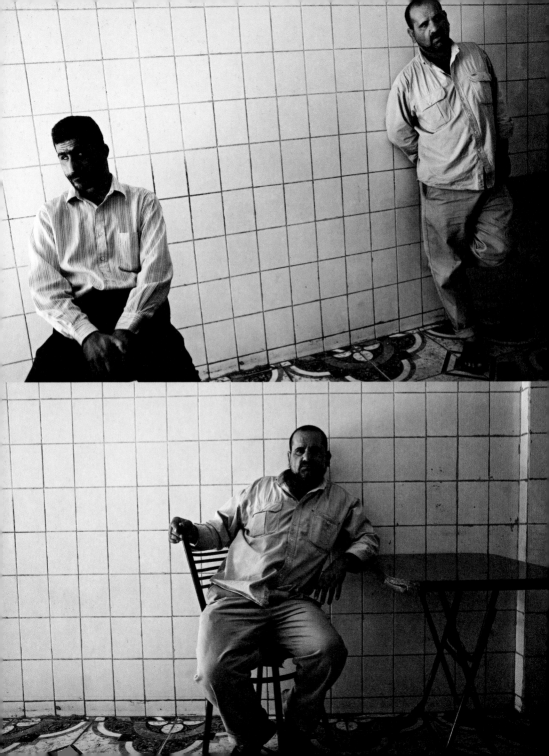

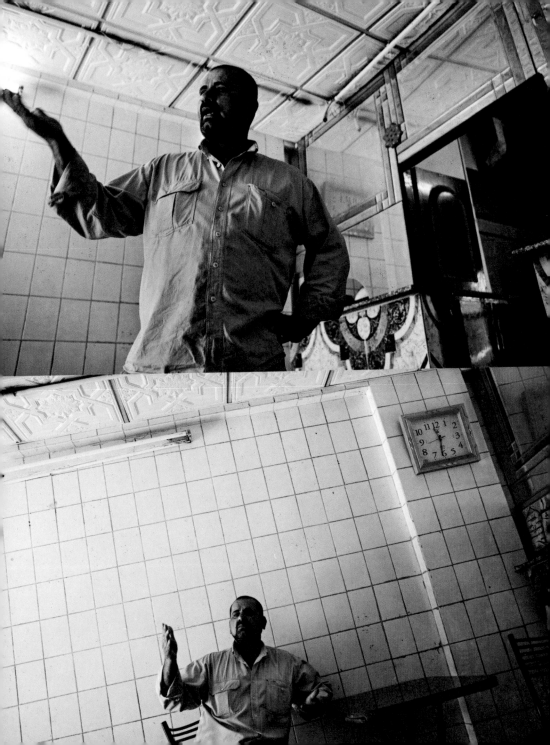

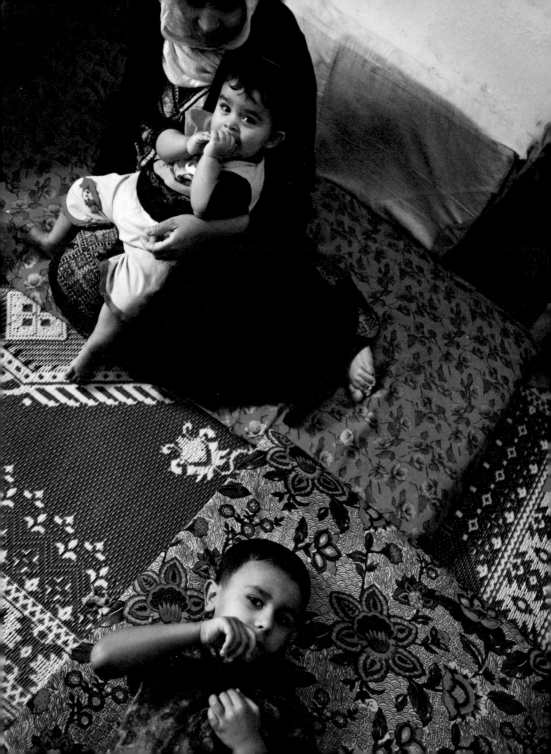

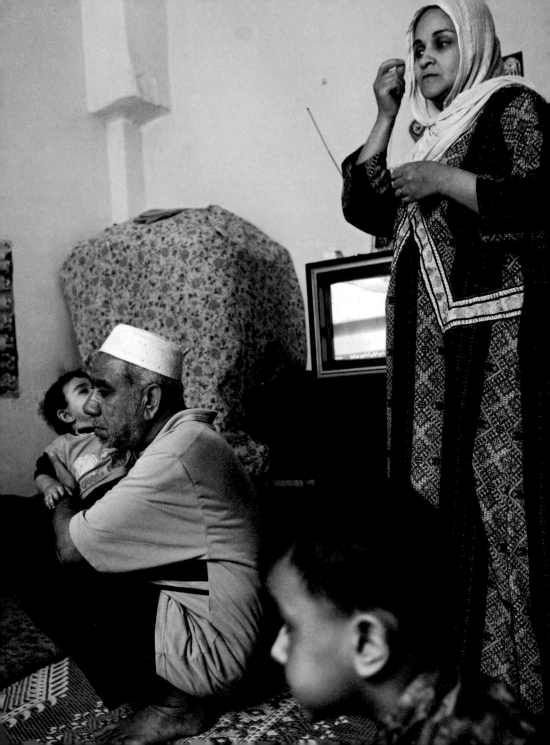

"We depend on aid to survive."

I left Iraq in December 2003 because my life was threatened. I am a longtime member of the Baath Party. I first joined in 1963, at the age of fifteen. I was promoted to a leadership position in 1973 and later found employment in the Oil Ministry. I retired in 1987 and became a trader with a good business in import/export. After the invasion of Kuwait in 1990, my situation became more difficult because I refused to deal with goods that came from Kuwait—as a Muslim, one should not deal in stolen property. I felt that what came from Kuwait had been stolen. During the subsequent sanctions, it became even more difficult.

After the threats, I decided to come to Syria because my brother lives here. But I have been threatened here, too. Someone stopped me in the street, a stranger, and said, "If you are a man, go to Baghdad and we'll deal with you there."

I have a pension in Iraq, but since 2003 I have not dared to return, and there is no one who can collect it for me: it's too dangerous. We depend on aid to survive. We receive food items from Saudi Arabia—oil, vegetables, etc. For two months we have supported ourselves in this way. But I don't know whether it will continue. Last month I had to sell my wife's gold necklace to pay rent.

I cannot go on with this life. I have five children. Their mother died a long time ago. I try to give them affection and to raise them to be responsible for themselves, but we need help. It's too much pressure. I am against terrorism and against all forms of violence.

"I cannot go on with this life. . . . It's too much pressure."

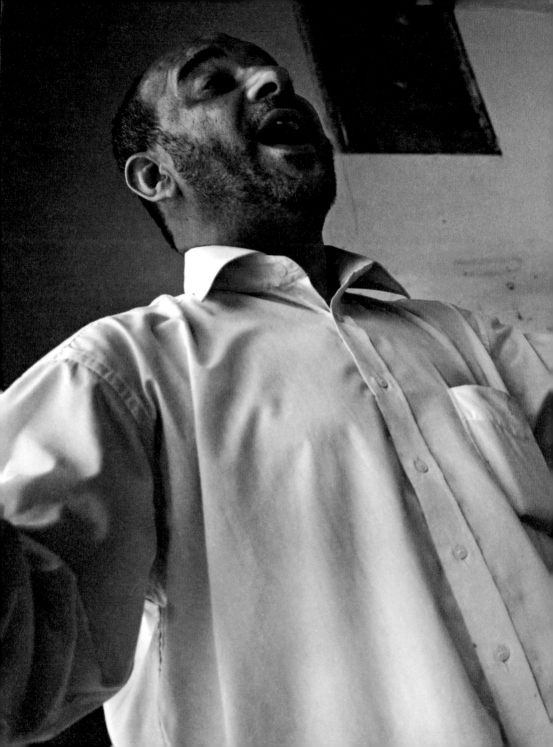

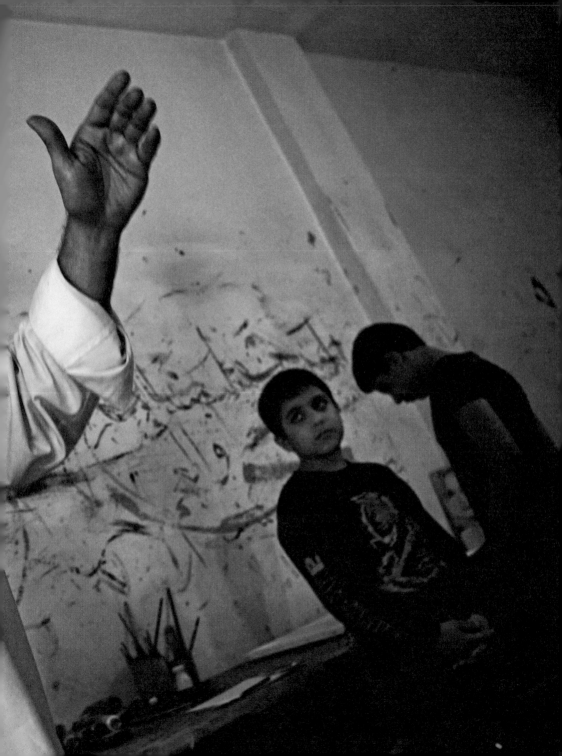

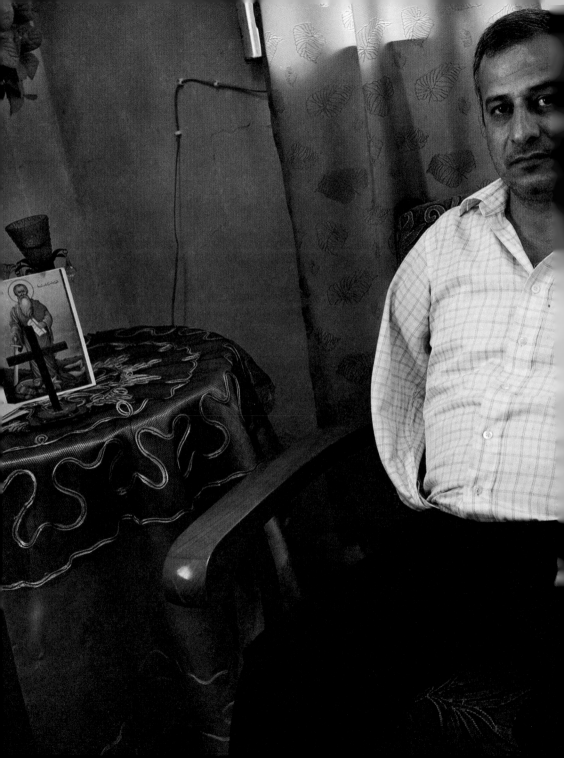

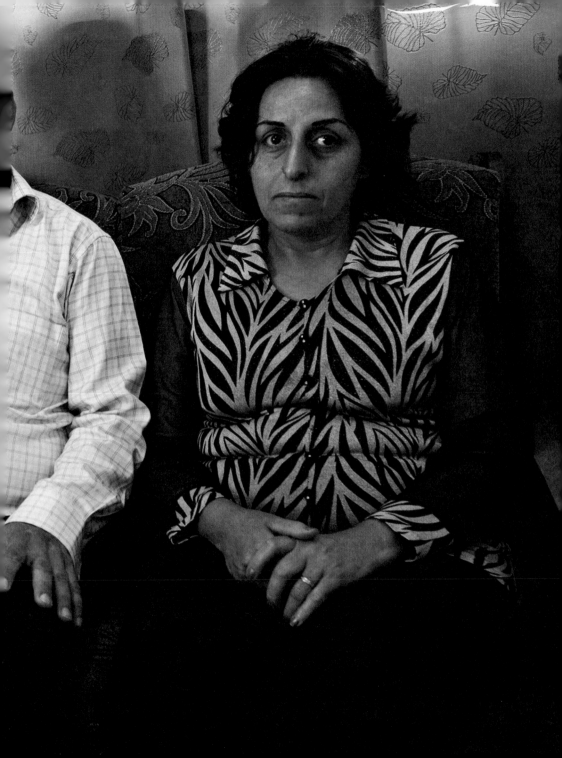

IN A SURVEY OF IRAQI
REFUGEES IN SYRIA,
ONLY 4 PERCENT HAVE
PLANS TO RETURN
TO THEIR HOMELAND.
NEARLY 90 PERCENT HAVE
NO PLANS TO RETURN,
WHILE THE REMAINING
6 PERCENT DON'T KNOW
WHAT THE FUTURE
HOLDS FOR THEM.[12]